MAJOR WORLD NATIONS
LIBYA

Renfield Sanders

CHELSEA HOUSE PUBLISHERS
Philadelphia

Chelsea House Publishers

Copyright © 2000 by Chelsea House Publishers,
a division of Main Line Book Co.
All rights reserved.
Printed in Malaysia

First Printing.

1 3 5 7 9 8 6 4 2

Library of Congress Cataloging-in-Publication Data

Sanders, Renfield.
Libya / Renfield Sanders.
p. cm. — (Major world nations)
Includes index.
Summary: Surveys the geography, history, economy, culture, and people of
Libya, the fourth largest country in Africa whose terrain is more than
ninety-seven percent desert.
ISBN 0-7910-5388-1 (hc.)
1. Libya—Juvenile literature. [1. Libya.] I. Title.
II. Series.
DT215.S24 1999
961.2—dc21 99-19183
CIP

CONTENTS

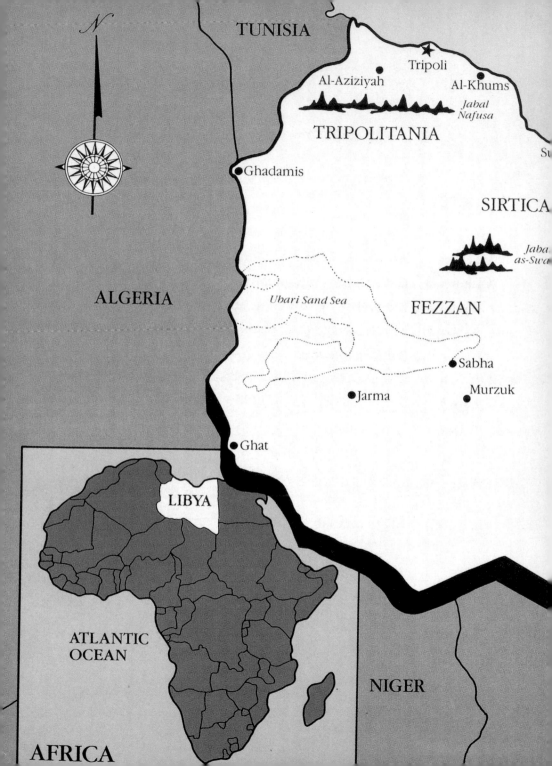

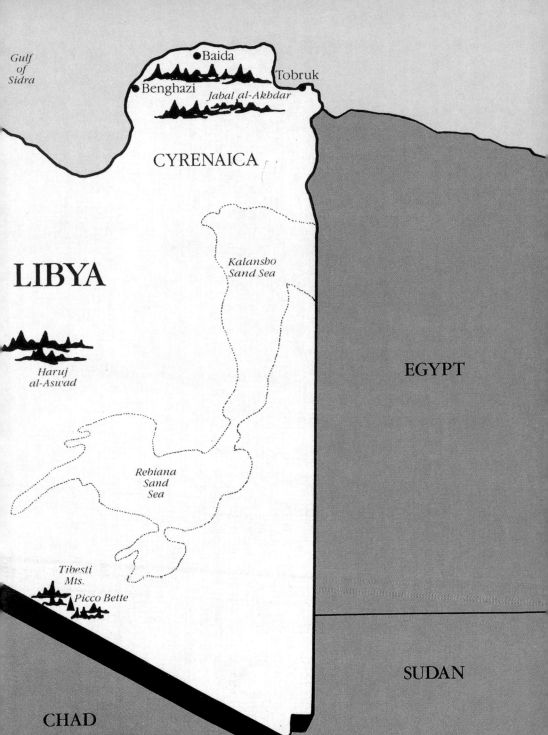

FACTS AT A GLANCE

Land and People

Official Name	Socialist People's Libyan Arab Jamahiriya
Location	Northern Africa between Egypt and Algeria
Area	1,143,700 square miles (1,758,700 square kilometers)
Climate	Mediterranean on coast; dry desert in interior
Capital	Tripoli
Other Cities	Benghazi, Tobruk
Population	5,690,000
Population Distribution	Urban, 86 percent; rural 14 percent
Mountains	Tibesti, Jabal Nafusa, Jabal al-Akhdar
Highest Point	Picco Bette, 7,500 feet (2,286 meters)
Official Language	Arabic
Other Languages	English, Italian
Ethnic Groups	Berber and Arabs, 97 percent

Religions	Sunni Muslim, 97 percent
Literacy Rate	76.2 percent
Average Life Expectancy	65.44 years

Economy

Natural Resources	Oil, natural gas
Division of Labor Force	Industry, 31 percent; services 27 percent; government 24 percent; agriculture, 18 percent
Agricultural Products	Olives, dates, peanuts (groundnuts), citrus fruit, wheat, barley
Industries	Petroleum, textiles, handicrafts
Major Imports	Machinery, transportation equipment, food
Major Exports	Crude oil, refined petroleum products, natural gas
Currency	Libyan dinar

Government

Form of Government	Socialist state (military dictatorship)
Government Bodies	General People's Congress
Formal Head of State	Muammar Qaddafi (no official title)
Head of Government	Secretary of the General People's Committee (premier)

HISTORY AT A GLANCE

8000 B.C.	Wandering nomads settle in the coastal regions of North Africa.
2000 B.C.	The Berbers arrive in North Africa and become the main inhabitants.
1500-1000 B.C.	The land that comprises present-day Libya is divided into three regions–Cyrenaica, Tripolitania, and Fezzan.
8th century B.C.	The Phoenicians establish trading posts and settlements along the North African coast. They found the city of Carthage which would become a major power in the area.
7th century B.C.	The Greeks start colonies in North Africa. They found the city of Cyrene.
525-100 B.C.	Various groups conquer the territories in North Africa including Darius I of Persia, Alexander the Great, and Ptolemy of Egypt.
96-46 B.C.	Rome takes control of Cyrenaica and Tripolitania, linking the two regions for the first time.

1st-4th centuries A.D.	The Romans bring Christianity to the North African cities.
4th century A.D.	Arabs introduce the camel to the people of North African deserts giving them greater mobility.
642 A.D.	The Arab Muslims, who have been gradually taking over much of North Africa attack Cyrenaica and Tripolitania.
7th-9th centuries	Almost all of the people in the area convert to the Islam religion and Arabic becomes the language of the region.
1051	Another large influx of Arabs takes place and they settle permanently in the area, intermarrying with the local Berber population.
16th century	The Turkish Ottoman Empire invades North Africa.
1711	Ahmad Karamanli leads a revolt against the Ottoman Turks. He becomes a regional king and his family reigns until 1835.
16th-17th centuries	Pirates rule the Barbary Coast (as the coast of Libya was then called) making Tripoli their base of operation.
1801-1805	The United States sends naval troops to the Barbary Coast after pirate attacks on American ships.
1835	The Ottoman Empire tightens its hold on Libya. An Islamic brotherhood, the Sanusiyah, is formed which believes in a strict, puritanical form of Islam. The Sanusi brotherhood gradually gains political power in Cyrenaica.

11

1911	Italy in its war against the Turks claims Libya and lands its troops on the coast. Sanusi resistance halts the Italians at the coast.
1918	After World War I the Allies allow Muhammed Idris to rule the interior of Cyrenaica but give Italy control of the rest of the area.
1922	Italy sends a governor to subdue all resistance. The Sanusi fighters resist the Italians under the leadership of Omar al-Makhtar.
1930s	Italians carry out a full scale colonization of the area. They relocate the Sanusis to the desert areas and take over any cultivable land.
1939-1945	During World War II the native North Africans join with the Allies against the Germans and Italians. North Africa becomes an important battleground of the war.
1949	After years of post-war debate the United Nations votes to make Tripolitania, Cyrenaica, Fezzan, and the desert between Fezzan and Sudan an independent country effective January 1952.
1951	On December 24 Muhammed Idris, the head of the Sanusiyah, officially declares Libya independent after he is overwhelmingly chosen its king. The king's rule is made absolute and political parties are prohibited.
1960s	Libya is torn between its Arab ties and its ties with Western countries and the United States. Huge deposits of oil are discovered by foreign corporations. Libya becomes a wealthy modern monarchy though many Libyans are not happy with its share of the oil profits.

1969 A swift coup d'etat led by Moammar Qaddafi deposes King Idris. Qaddafi evicts British and U.S. forces from military bases, forces oil companies to give Libya 51 percent of control and profits or leave the country, institutes new laws enforcing strict Muslim and Arab customs.

1970s Qaddafi breaks ties with the United States and Western Europe and seeks unity with other Arab nations.

1986 After years of accusations from the U.S. government for terrorist tactics Qaddafi launches missiles at American ships in the Gulf of Sidra. The U.S. retaliates with bombing raids on Tripoli and Benghazi.

1991 The first arm of the Great Man-made River is completed–a massive pipeline built to utilize underground water sources discovered in the 1970s.

1993 The United Nations approves embargoes on Libyan trade and air traffic because of Libya's suspected ties to the bombing of Pan Am flight 103 in 1988 and harboring of the suspected bombers.

1998 The UN sanctions against Libya continue as Libya refuses to make reasonable compromises over the release of the suspected bombers. Air travel continues to be limited and the economy suffers.

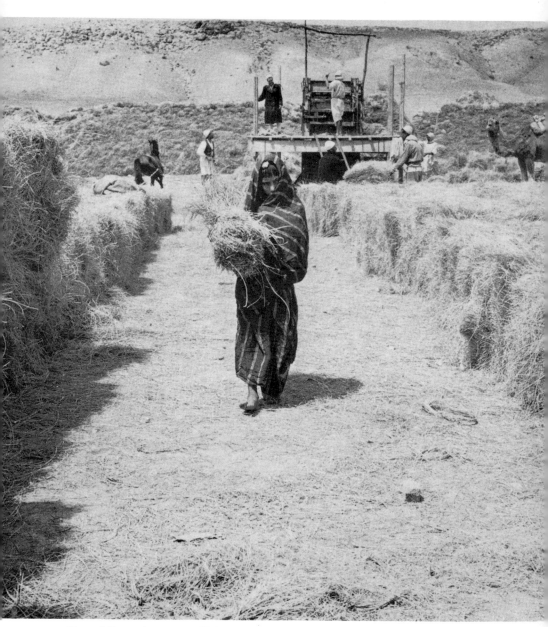

Many Libyan farmers still harvest crops the way their ancestors did.

1

An Ancient Land in Modern Headlines

Few nations were as newsworthy as Libya during the 1970s and 1980s. Under the government of revolutionary leader Moammar Qaddafi, who seized control of the country in 1969, Libya caught the world's attention with its aggressive behavior toward other nations, particularly the United States. But although Libya has been prominent in headlines, many people know little about it.

Located on the North African coast, Libya borders the Mediterranean Sea for 1,200 miles (1,920 kilometers) on the north and stretches 800 miles (1,280 kilometers) into the vast Sahara Desert to the south. Libya's neighbors are Egypt to the east, Sudan to the southeast, Chad and Niger to the south, Algeria to the west, and Tunisia to the northwest. The fourth-largest country in Africa, Libya is one-quarter the size of the continental United States. It covers an area of 675,200 square miles (1,748,700 square kilometers), of which slightly more than 97 percent is desert. With just over five and a half million inhabitants, Libya is

15

sparsely populated. The country has few resources other than oil, which it discovered in 1956.

Libya's name comes from the Lebu people, who in ancient times lived along the shore of the Mediterranean in what is now eastern Libya. Early Egyptian, Greek, and Roman historians used the word "Libya" to refer to all of Africa except Egypt, so the name appears in records of travel and warfare among the Mediterranean and African nations as early as 2000 B.C. Although its name is thousands of years old, the nation of Libya did not exist until 1951. Before that time, the area that is now Libya consisted of three very different lands with separate histories: Cyrenaica, Tripolitania, and Fezzan. The country's three main regions still go by these names.

The three regions became the Kingdom of Libya in 1951, but the Libyan people found it difficult to think of themselves as belonging to a single, unified country. Instead, they regarded themselves as members of smaller units: families, tribes, and *leffs* (loosely organized groups of tribes). Since taking power in 1969, Qaddafi has used two powerful tools—oil and Islam—to mold Libya's many tribes into a nation.

Oil brought sudden wealth into a land accustomed to poverty. Formerly one of North Africa's poorest countries, Libya began to earn large amounts of money by exporting oil in the early 1960s. To spread the wealth among all the people, Qaddafi established a socialist government. Government programs spent money on education and healthcare, and the standard of living increased by several thousand percent between 1951 and 1971. Improvements in

16

communications and transportation linked the residents of far-flung oases with those of the coastal cities. Money gained from the petroleum industry also paid for many military purchases, such as fighter planes and weapons. Its oil fields gave Libya power among other nations, and Qaddafi used that power to try to gain control of troubled African countries and to show hostility toward the United States and some European governments.

Petroleum is a mighty force in modern Libya, but the Islamic religion has done more to unify the country. Most Libyans have been Muslims—followers of Islam—since Arab Muslims from Saudi Arabia and Egypt swept across the Sahara in several waves of conquest and colonization between the 7th and 13th centuries.

Special towers freeze natural gas, one of Libya's energy resources.

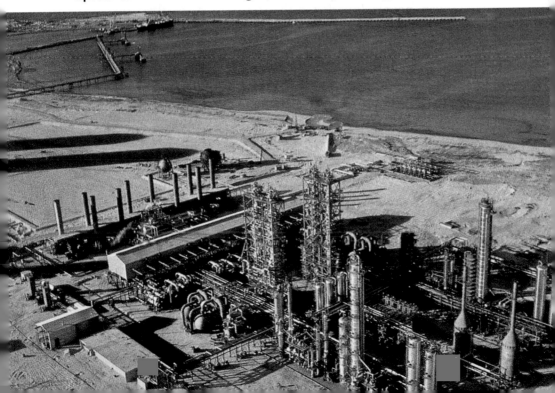

The Arabs intermarried with the native Berbers and soon dominated the population, and Islam took the place of other religions.

Certain Muslim nations are somewhat tolerant of other faiths, but Qaddafi urged Libyans to practice a severe, fundamentalist form of Islam. He favored strict adherence to age-old customs, beliefs, and religious laws, many of which seemed primitive or unjust to non-Muslims. Qaddafi's religious zeal helped him rise to power and won him many fervent followers. He called for a pan-Islamic union (an international union including all Arabic peoples and no non-Muslims), but most of his attempts to form alliances with other Arab or African nations failed.

After a series of border wars with neighboring nations and disputes with the United States, Qaddafi appeared to lose esteem at home and abroad. But he has retained his position as Libya's leader into the 21st century. And as long as he remains in control of Libya both he and his nation will most likely continue to make headlines around the world.

Geography and Climate

Libya consists almost entirely of hot, arid desert, although fossils from the country's interior show that it was covered by the sea many thousands of years ago. Volcanic activity formed some rocks in the southern Sahara region of Libya, but the volcanoes became inactive long ago. Today, Tripolitania and Cyrenaica have the greatest topographical variety.

Tripolitania, in the northwest, sits on a large plain called the Jefara, which rises from foothills on the coast to about 1,000 feet (330 meters) in altitude and covers 10,000 square miles (16,000 square kilometers). A mixture of salt marshes, sand dunes, and steppes (grassy plains), the Jefara contains most of Libya's population and its largest city, Tripoli. Although the soil is somewhat salty, crops can grow with the help of irrigation. On its southern edge, the Jefara borders the Jabal Nafusa, a range of low mountains that stretches for 212 miles (340 kilometers) from west to east. The Jabal Nafusa, mostly weathered limestone rock, rises to

Libya's northern border is the Mediterranean Sea.

altitudes of 2,000 to 3,000 feet (670 to 1,000 meters) and creates a barrier between the Jefara and the Sahara.

A similar range of low mountains separates the coastal region from the Sahara in Cyrenaica, in the northeast. This range, called the Jabal al-Akhdar, or Green Mountains, is about 100 miles (160 kilometers) long and extends inland for about 20 miles (32 kilometers). Libya's second-largest city, Benghazi, is located at the western end of the mountain range. Although it is hilly, the Jabal al-Akhdar is Libya's most fertile area. The limestone soil is rich in potash and phosphoric acid, chemicals often used in fertilizers. In the northern part of the Jabal al-Akhdar, where cool, damp Mediterranean winds carry moisture, is Libya's only forest: a tangle of thorny scrub and low juniper trees stunted and twisted by the wind. Elsewhere in the hills, herds of livestock graze on thick grass.

The chief feature of the flat Sirtica, situated along Sidra's gulf coast between Tripolitania and Cyrenaica, is the *sabkhahs*—salt lakes that form when seawater accumulates behind sand dunes and then evaporates in the sun. Desert-dwellers gathered and traded salt from them in ancient times, and some salt production continues today.

Inland, behind the coastal plains and the mountain ranges, lies the immense Saharan plateau, a wilderness of wind-blown sand and bare rock dotted with oases that follow the paths of underground rivers. Libya has no year-round rivers, only *wadis*, dry valleys that carry water for a few months during the rainy season. Wadis can flood quickly in the rare event of a desert thunderstorm.

lake discovered in 1968 may someday provide water for irrigation and make farming or herding possible in the eastern reaches. Libya has no lakes above ground.

Fezzan, in the southwest, contains two smaller sand seas, the Ubari in the center of the region and the Murzuq in the south, on the border with Niger. Between and around these empty fields of sand, however, run underground streams and rivers that often break through the earth's surface as deep wells. Many villages and small towns have grown up at these oases. The ruins of *foggara*, ancient irrigation systems of subterranean tunnels, show that Fezzan was more densely populated and widely farmed centuries ago than it is today. Fezzan is mostly flat, but in the far south, an

Underground streams irrigate Libya's olive, lemon, and fig orchards.

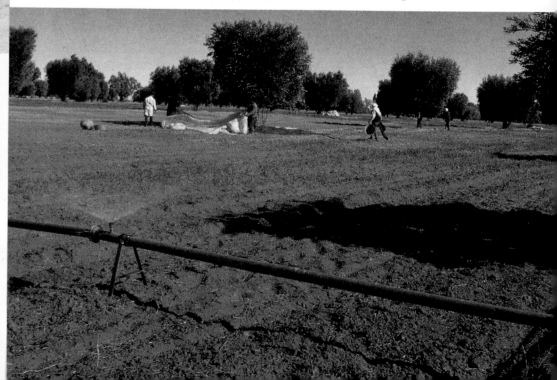

arm of the Tibesti mountain range of Chad reaches north across the border. Picco Bette, a rugged peak of the Tibestis, rises here in the lonely wasteland on the Libya-Chad border. At 7,500 feet (2,286 meters), it is the highest point in Libya.

The Mediterranean Sea and the mighty Sahara Desert control Libya's climate, making most of the country hot and dry during the day and sometimes quite cold at night. The difference between day and night temperatures is less extreme along the coasts of Tripolitania and Cyrenaica, where a more Mediterranean climate prevails.

During the hottest months, July and August, temperatures in Tripoli range from 62 degrees Fahrenheit (17 degrees Celsius) at night to 86 degrees Fahrenheit (30 degrees Celsius) during the day. In winter, the average nighttime temperature is 47 degrees Fahrenheit (eight degrees Celsius) and the average daytime temperature is 61 degrees Fahrenheit (16 degrees Celsius). Temperatures deep in the interior of the country are usually 20 degrees Fahrenheit (three degrees Celsius) hotter or colder than on the coast, although the highest temperature ever recorded in Libya—136 degrees Fahrenheit (58 degrees Celsius)—was at al-Aziziyah on the Jefara plateau.

Rainfall is sparse in all parts of Libya and almost nonexistent in some interior regions. Benghazi receives an annual average of eight inches (200 millimeters) of rain; Tripoli receives about 16 inches (400 millimeters). The highlands of the Jabal al-Akhdar in Cyrenaica are the wettest places in Libya, with 24 inches (600 mil-

For centuries, sand winds have plagued travelers in Libya.

limeters) of rain yearly. Most of the rain in the coastal regions falls in short but torrential downpours during the winter. But rainfall is irregular, and severe droughts afflict the coast in about two of every 10 years. Inland rain is even less frequent. Many parts of the Saharan region can be rainless for as many as 200 days in a row. Many meteorologists consider Sabha, a small city in Fezzan, the driest place in the world.

One special feature of Libyan weather is both awe-inspiring and deadly. It is the *ghibli*, an intensely hot wind that blasts northward from the heart of the Sahara two or three times each year. Signaled by a brief, ominous lull in local winds, the ghibli carries huge quantities of sand and dust. It blows for three days, hiding the sun and turning the sky reddish brown with sand blown as high as 600 feet (200 meters). The ghibli can raise the temperature by 40 degrees Fahrenheit (22 degrees Celsius) within an

26

hour. Travelers struck by the ghibli may become lost, as the sand prevents them from seeing farther than 60 feet (20 meters). If they cannot find shelter, they are likely to die of dehydration. Scattered through the Saharan wastes of southern Libya, half-buried in sand by the ceaseless winds, lie the bones of men and camels—sometimes entire caravans—who fell victim to the ghibli. One 18th-century British explorer who lived through the ghibli said that it was "like a breath from the very ovens of Hell."

The Sahara was not always desert. During the last great Ice Age (around 10,000 B.C.), when glaciers covered much of Europe, the Sahara was an enormous, grassy plain, or savanna, dotted with forests, streams, and lakes. It even contained a huge inland sea. Elephants, rhinoceroses, giant buffalo, and hippopotamuses were abundant in lands that are now lifeless desert. They left their bones and even their footprints behind them in stone. But fossils are not the only evidence of the Sahara's former fertility. Primitive humans, hunters who settled the area in prehistoric times, painted and carved images of now-extinct animals on cave walls throughout the Saharan mountains, probably as part of magic rituals to bring about good hunting. As the world warmed and the ice sheets retreated to the north, the Sahara gradually grew hotter. The lakes and streams dried up, the vegetation adapted to desert conditions or died, and most of the animals disappeared.

When rainfall is adequate, several kinds of grasses and herbs carpet the northern coastal strips of Tripolitania and Cyrenaica. One of the most common wild plants is the asphodel, an herb related to the lily that is mentioned in many ancient myths and

poems. Farmers grow cereal grains, such as barley, and cultivate orchards of oranges, figs, date palms, lemons, olives, and apricots along the coast using complicated networks of irrigation canals. A common cash crop (grown for sale rather than for local use) is esparto grass, sometimes called Spanish grass. Manufacturers use it in making paper, and Spanish craftsmen weave it into tough ropes and sturdy shoes. Esparto grass was Libya's chief export before the country discovered oil.

Farther south, hardy plants grow in isolated patches on the fringes of the desert and are sometimes harvested. They include saltwort (used in making soda ash for chemical processes) and wormwood (an ingredient in some medicines and liquors). The desert oases bloom with date palms, Arab acacias, low tamarisk

Libyan farmers keep hardy livestock that can survive on sparse food.

trees, wild pistachios, and henna shrubs. Desert tribes use the leaves of the henna to dye their hands, feet, and hair a deep red—a cosmetic custom that the ancient Egyptians also practiced.

Like its plant life, Libya's animal life consists mostly of species adapted to hot, arid weather. These include desert rodents (such as the jerboa and the guinea pig), foxes, wildcats, leopards, jackals, gazelles, hyenas, and skunks. Insects are numerous, especially locusts and butterflies, which migrate across the interior in great clouds. Reptiles, such as lizards and chameleons, are common. Poisonous adders and kraits (small, venomous snakes) lurk in some wells and water holes. Native birds include wild ringdoves, partridges, larks, prairie hens, eagles, hawks, and vultures.

Farmers and herdsmen keep horses, goats, sheep, donkeys, and oxen, but perhaps the most important domestic animal is the camel. Camels lived in Libya many thousands of years ago, but they died out before human settlement began. In the fourth century A.D., Arabs brought to Libya hardier camels, suited to desert life.

Today, one-humped camels flourish throughout North Africa, where they are indispensable means of transportation and sources of milk, wool, and meat. Desert travelers prize the mehari, or fast riding camel, most of all. A fine mehari's pedigree is as valuable and as carefully studied as that of an Arabian stallion. Although automobiles and even helicopters have made desert travel easier for city-dwellers, most of the oasis farmers and nomadic tribes people of southern Libya still depend on their meharis to carry them across the desert.

3

Early History: Invasion and Conquest

The earliest inhabitants of Libya were prehistoric hunter-gatherers, wanderers who lived off the land and made no permanent settlements. By about 8000 B.C., however, these people had begun to establish small villages and plots of cultivated land. As the climate grew hotter and the desert advanced northward, people gradually migrated to the coastal regions or settled in the oases. Meanwhile, other groups in search of land began invading North Africa from the more crowded regions of the eastern Mediterranean.

The Berbers were the most numerous of these colonizing forces. They arrived in North Africa before 2000 B.C. and outnumbered the small native population of Libya, which they quickly absorbed. By 1500 B.C., virtually all the inhabitants of Libya were Berber farmers and herdsmen belonging to many small but related tribes. From that time on, the early history of Libya is the story of the three regions: Cyrenaica, Tripolitania,

Hunters in prehistoric Libya left their marks with rock paintings.

and Fezzan. Because of the harsh deserts separating these regions, for centuries they had more contact with neighboring settlements than with one another, so each developed independently.

The kings of the Lebu tribe of Cyrenaica led frequent raids against Egypt across 600 miles (960 kilometers) of intervening desert in the years 1500 to 1000 B.C. Although they were unable to capture any Egyptian territory, the Lebu were a fierce people. Many became mercenary soldiers (soldiers for hire) in the Egyptian army, and in 940 B.C. these Libyan warriors took over the government of Egypt. They and their descendants ruled Egypt and Cyrenaica as pharaohs until about 630 B.C., when the Greeks conquered and settled Cyrenaica.

Crete and other Greek islands in the Aegean Sea were overpopulated in the seventh century B.C., so the Greeks were eager

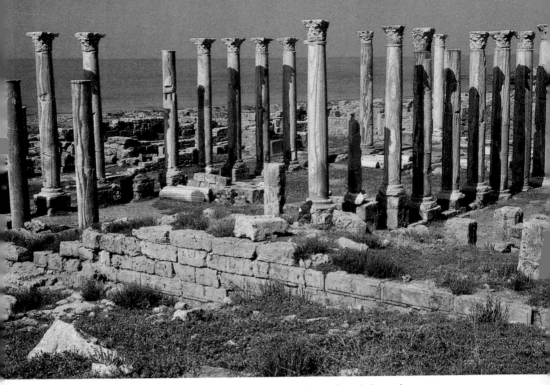

Ruins of Cyrenaica are tributes to the city's Greek founders.

to start colonies in North Africa. They founded the city of
Cyrene, which gave the region its name. Its ruins are located on
the coast near present-day Baida. The first Greek ruler of Cyrene
changed his name to Battus, a Berber word meaning "king," and
the new settlers and the natives lived together fairly peacefully
and even intermarried. During its heyday in the 6th century B.C.,
Cyrene was as wealthy and magnificent as any other Greek city,
with many grand temples to honor Greek gods. The Greek
Cyrenaicans traded in fruit and grain, but their most profitable

32

export was a rare medicinal herb called *silphium*, which has become extinct.

The Greeks founded other cities in Cyrenaica—notably Euhesperides, today known as Benghazi. Beginning in 525 B.C., Darius I of Persia, Alexander the Great, and Ptolemy of Egypt conquered the region in turn. Under Ptolemy's descendants, Cyrenaica was once again a province of Egypt for several centuries. Some local noblemen of this time were buried in Egyptian-style tombs that still remain in the deserts of southern Cyrenaica, near the Egyptian border. During this period, the cities of the region remained Greek in character and were free to run their own affairs. They developed a form of democracy like that of Athens. In 96 B.C., Rome took control of Cyrenaica, and in 46 B.C., for the first time, Cyrenaica had some connection with Tripolitania when Rome conquered that province as well.

The region that later became Tripolitania entered Mediterranean history in the eighth century B.C., when the seafaring Phoenicians—whose homeland was present-day Lebanon—

Early settlers built desert tombs in what is now Tripolitania.

established trading posts and settlements along the North African coast. They founded Lepcis (later called Leptis Magna), Sabratha, and Oea, the cities for which the Romans later named the region Tripolitania, or "land of the three cities." In addition, the Phoenicians founded Carthage, in what is now Tunisia. Carthage eventually became independent of Phoenicia and ruled part of Spain and most of western North Africa, including the cities of Tripolitania. This prevented the Greeks from expanding their territory west from Cyrenaica.

Most of the Carthaginian empire's settlements along the Libyan coast were small, with fewer than 200 people. Called *emporia* by the Greeks, these settlements served as anchorages and watering places for Carthaginian ships and as markets where Berber tribes from Fezzan brought articles for trade. The three largest Tripolitanian emporia—Lepcis, Oea, and Sabratha—grew wealthy from taxes paid by the Berber caravans that crossed the Sahara, bringing precious gems, gold, and slaves north from the heart of Africa. Although at least one Carthaginian traveler, named Mago, is said to have crossed the great desert twice, coastal dwellers usually left such adventures to the scattered Berber tribes of the interior. Over time, the cities of Tripolitania gained still greater wealth by exporting fish, fruit, and grain to the rest of the empire.

The Carthaginians forced the native Berber people to pay high taxes—sometimes as much as half of their crops, livestock, or earnings—and to send many regiments of men to fight in Carthage's battles. As a result of prolonged war with Rome, Carthage grew weak in the second century B.C. A Berber ruler named King

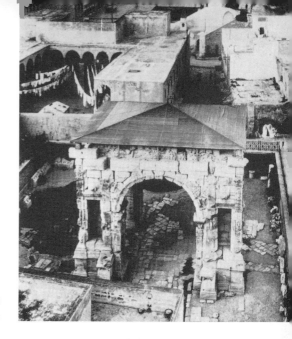

**Traces of the Roman Empire
exist in present-day Tripoli.**

Masinissa, a shrewd ally of Rome who, as a young man, had fought for Carthage against the Roman legions in Spain and recognized their invincibility, seized control of Tripolitania. His family ruled the region until, after the fall of the Carthaginian empire, Julius Caesar claimed Tripolitania for Rome in 46 B.C.

Tripolitania flourished as part of the Roman empire, especially under Emperor Septimus Severus, who came from Leptis Magna and ruled from 193 to 211 A.D. The Romans brought Christianity to the Mediterranean cities of Libya at this time. They developed ingenious systems of irrigation to make the Jefara fertile. They introduced the cultivation of olive trees and turned Tripolitania into an important source of olive oil. They exported so much wheat and barley from the fields of the Jefara that Tripolitania was often called "the granary of the empire."

35

Proconsuls appointed by the emperor governed both Cyrenaica and Tripolitania as provinces of the empire. Roman officers in Libya commanded a legion of about 13,000 soldiers, many of them Berbers, who were assigned to keep the famous *pax Romana*, or Roman peace. But the desert-dwellers of the interior, who never fully submitted to Roman rule, severely tested their power.

Beginning in the fifth century B.C., the Garamantis, a Berber tribe of Fezzan, ruled a huge trading empire that stretched northwest to Ghudamis on the Tunisian border and southward to Lake Chad. From its fortified capital, Jarma, it sent caravans of merchants to purchase slaves, gold, and gems in the south and then sold these treasures to the Carthaginians and Romans at a high profit.

The Romans built many forts in Libya to protect these caravans from bandits—and to protect the coastal cities from the Garamantis. At one time, a line of forts stretched from Leptis Magna to Ghudamis. The sun-baked ruins of a few of these stone and clay structures exist today, and amateur archaeologists still find an occasional Roman coin or wine bottle. The forts marked a line between settled, Romanized Libya and the wild, nomadic desert, and Rome was unable to advance its influence far beyond them. When the empire of the Garamantis finally collapsed because of struggles for power among various branches of the family, other tribes in the oases of Fezzan rose to prominence. After the Arabs introduced the camel to Fezzan in the fourth century A.D., the nomads and desert warriors had greater mobility

than the Roman legions and launched occasional attacks against the cities of northern Libya.

As the strength of the Roman Empire gradually declined after the fourth century, many parts of Cyrenaica and Tripolitania, both on the coast and in the interior, declared themselves independent. Rome eventually reconquered the coastal regions, but even the fierce German Vandals, who conquered Rome in 410 A.D. and swept on to Tripolitania, could not subdue the desert tribes. By the middle of the 6th century, Tripolitania and Cyrenaica belonged in name only to the Eastern Roman Empire based in Byzantium (present day Istanbul, the chief city of Turkey). In practice, Byzantium had little influence in the coastal provinces and none at all in the interior. But although the Mediterranean empires had failed to hold Libya, a new conquering power was advancing from the east.

The Islamic empire originated in Arabia in the first half of the seventh century, when the prophet Muhammad founded the reli-

The prophet Muhammad, founder of Islam, gained many followers who attacked and then seized control of Cyrenaica and Tripolitania.

gion of Islam. Within a few years, by a combination of conquest and conversion, the Arabs had spread Islam throughout the Middle East, northern India, and Egypt. From Egypt, armies of Muslims (followers of Islam) led by Arab officers swept westward toward the Atlantic. Eventually, they controlled all of North Africa and part of Spain.

The first Muslim attacks on Cyrenaica and Tripolitania took place in 642 A.D.. Although the native Berbers offered some resistance, they eventually succumbed. Historians have suggested that the Berbers may have been more willing to accept the rule of another tribal, desert-dwelling people than they had been to submit to the urbanized Mediterraneans. Within just two centuries of the first contact between Berbers and Muslims, almost all of the people of Libya had converted to Islam, and Arabic had become the national language, although the original Berber language survived and contributed many words to the vocabulary.

Despite their powerful influence, the Arabs in Libya were few in number at this time. Perhaps no more than 30,000 Arabs actually arrived in the region during the first several centuries of the Islamic conquest. In succeeding centuries, as various dynasties battled among themselves in far-off Arabia for control of the vast empire, new waves of Arab soldiers reached North Africa. In 1051, the Arab governors of Tunisia, Tripolitania, and Cyrenaica revolted against the powerful Fatimid dynasty of Cairo. The Fatimids sent a huge force of Arabs to subdue the rebellious provinces. The force consisted of two entire tribes, the banu-Hilal and the banu-Sulaym, that had migrated from Arabia to southern Egypt.

These two tribes led the real Arab invasion of North Africa, for they brought with them their families and livestock and settled permanently throughout the area in great numbers. In Libya, they easily overran the Berbers and intermarried with the local population. The Arab influence in Libya became dominant and permanent.

During the next several centuries, the Islamic rulers of Cairo claimed Cyrenaica, and the Islamic rulers of Tunisia claimed Tripolitania. Fezzan was unclaimed, but its busy commerce continued.

In the 16th century, still another mighty power appeared in North Africa. The Ottoman Empire, an Islamic dynasty based in Turkey, had already conquered Egypt. Around 1510, a Tunisian pirate named Khayr ad-Din helped the Ottomans to take the rest of North Africa. Ad-Din, nicknamed Barbarossa, lived on the island of Djerba near the border between Tunisia and Tripolitania and preyed on Spanish ships. Seeking greater power, he betrayed his oath of loyalty to the Tunisian sultan and pledged allegiance to Selim I, the Ottoman sultan. Selim sent 6,000 armed soldiers from Turkey to serve under the pirate, who captured city after city along the North African coast. He and his sons after him took the title *beylerbey,* or supreme commander. They ruled Turkish North Africa until 1587.

During the 17th century, local rulers, or *beys,* appointed by the Turkish sultan governed Libya and other Ottoman possessions in North Africa. By the end of the century, Libya contained a large population of *kouloghis,* the children of Turkish soldiers and

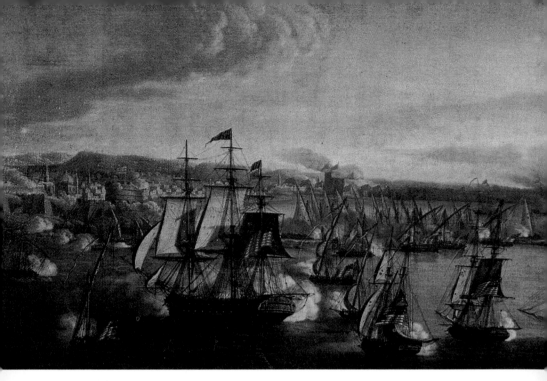

Berber women. In 1711, Ahmad Karamanli led a revolt of the kouloghis, supported by caravan merchants and pirates, against the empire. He took the title *pasha*, meaning regional king under the sultan, and his family reigned in Libya until 1835.

The Karamanlis ruled on land, but pirates ruled the seas along the Barbary Coast (a name derived from "Berber"), as the coast of Libya was then called. The pirates, who maintained a stronghold in Tripoli by means of generous gifts to the Karamanlis, grew so bold that they openly carried out a form of nautical extortion. They demanded high fees for safe conduct from all foreign shippers. In 1801 they increased their fees, and the United States refused to pay. The pirates attacked American ships. In retaliation, the United States sent naval troops to the Barbary Coast to

U.S. Naval troops fought pirates along the Barbary Coast.

fight the pirates in a war that lasted until 1805. The United States Marine Corps hymn, which begins, "From the halls of Montezuma, to the shores of Tripoli," refers to this punitive action. Large-scale French and English naval actions that took place in the Mediterranean during the Napoleonic Wars eventually wiped out piracy on the Barbary Coast.

In 1835, the Ottoman Empire took direct control of Libya away from the Karamanlis. But, although the empire held claim to Libya, it was growing weak and was troubled with wars and rebellions in many distant provinces. As the power of the empire waned during the 19th century, similar troubles flared up in Libya.

41

4

Modern History: Independence and Revolution

The most significant event in Libya after the Ottoman Empire tightened its grip in 1835 was the formation of an Islamic brotherhood, the Sanusiyah. Although it began as a religious order, the Sanusiyah was to play an important role in modern Libyan politics and culture.

Muhammad Ibn Ali al-Sanusi was an Algerian mystic who believed in a strict, puritanical form of Islam. He moved to Cyrenaica, where in 1837 he founded a religious fraternity that he named the Sanusiyah. His passionate preaching attracted many followers. The Sanusi brothers provided to the common people not only religious teaching but also money and food. As a result, the brotherhood had many loyal supporters who felt a strong unity with the Sanusi cause.

The Sanusis built their first *zawiyah*, or monastery, in 1843 near the ruins of the ancient coastal city of Cyrene. The order spread

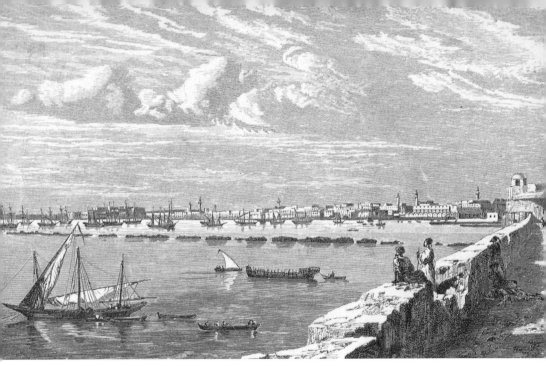

Conquerors and merchants used Tripoli's large harbor in the 1800s.

rapidly through all of Cyrenaica. Although the Sanusiyah eventually had many followers in other parts of Libya, especially in the southern deserts, the order remained strongest in the northeast. To keep his followers' purity from being corrupted by the cosmopolitan life of the coastal region, al-Sanusi, who came to be called the Grand Sanusi, moved his headquarters to the Jaghbub oasis near the Egyptian border. In 1895, his son and successor as Grand Sanusi, Sidi Muhammad al-Mahdi, moved still farther south, to the oasis of al-Kufrah. Al-Mahdi's nephew, Ahmad al-Sharif, became Grand Sanusi in the early 1900s.

At first, the Ottomans tolerated the Sanusiyah. The Turkish rulers hoped that the brotherhood would combat French influence,

which was spreading northward from French territories in Chad. After a few years, however, the Ottomans became uneasy about the Sanusiyah's political power in Cyrenaica. But before internal disputes could arise, Libya once again faced the threat of invasion.

Italy went to war with Turkey in 1911. Because the Italians had banking interests in Libya and wanted to acquire African colonies, they used the war as an excuse to claim Libya and landed many troops on the coast. The Ottoman forces withdrew and asked for peace in 1912, but Sanusi resistance halted the Italian invasion at the coast.

After World War I, however, the Allies forced al-Sharif to give up command of the Sanusiyah because he had sided with the Turkish forces against Italy. His cousin, Muhammad Idris al-Mahdi as

Sanusi troops fiercely defended Cyrenaica against the Italians.

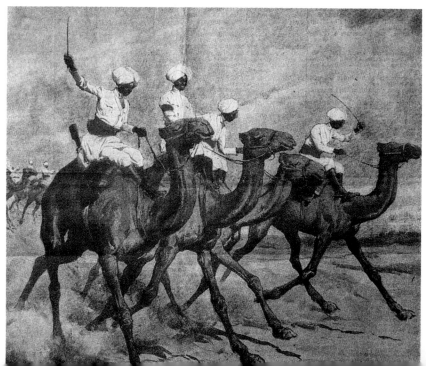

Sanusi, became head of the order. The Allies permitted Idris to rule the interior portions of Cyrenaica, but gave Italy control over the rest of Libya.

When the Fascist government came to power in Italy in 1922, it sent a strong governor named Giuseppe Volpi to Libya to subdue all resistance to Italian rule. During his first year of governorship, Volpi stamped out a plot to make Idris the prince of Tripolitania. Idris fled to Egypt, but the Sanusi fighters continued to resist the Italians. The leader of the resistance was a Sanusi *sheikh*, or chieftain, named Omar al-Makhtar, who led bands of camel-riding Muslim monks on guerrilla raids against Italian outposts in Cyrenaica. After 20 years, the Italians finally hunted down, captured, and executed the freedom fighter in 1931, when he was a very old man. He is now a hero to the Libyan people.

During the 1930s, the Italians carried out massive colonization projects. They attempted to destroy the Sanusiyah by forcibly relocating the nomads in inhospitable, arid zones. They confiscated from the natives the best land for cultivation. In 1935, Italian dictator Benito Mussolini launched a program called "demographic colonization, in which he shipped many thousands of Italians—including criminals and very poor people—to Tripolitania and Cyrenaica. By the outbreak of World War II in 1939, some 150,000 Italians had settled in Libya. They made up 18 percent of the country's total population.

Many Libyan nationalists (people who supported the idea of an independent nation) saw the North African campaign of World War II as an opportunity to win freedom from the Italians. In 1940,

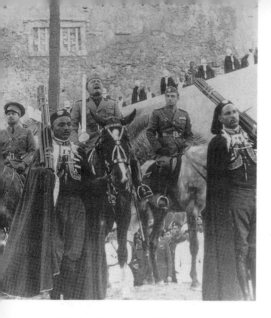

Libyan officials supported Mussolini during his visit in 1937.

Idris formed a Libyan army in Cairo. He joined with the remaining Sanusi forces in Cyrenaica to support the British against the Germans and Italians, who were using Libya as a base during their attempt to gain control of Egypt. Much fierce fighting occurred in the hostile desert around the border between Egypt and Libya.

The Cyrenaican city of Benghazi was the principal supply port of Germany's Afrika Korps, commanded by Field Marshal Erwin Rommel, who was called "The Desert Fox" as a tribute to his skill and success in desert warfare. In addition, German bombers operating out of three airfields near Benghazi caused much damage to Allied ship convoys crossing the Mediterranean. The Allies made many attempts to capture Cyrenaica. The scene of the greatest battles, however, was not Benghazi but Tobruk, a port city some 250 miles (400 kilometers) to the east. The British captured Tobruk from the Italians in January 1941 and later held it against an eight-month siege by combined German and Italian forces led by

Rommel. The Germans took the city in June 1942 but the British and French recaptured it the following November. Thousands of soldiers fell on both sides, and the sands around Tobruk still contain rusty barbed wire, the remnants of burned-out tanks and trucks, and fragments of exploded artillery shells.

Cyrenaica changed hands three times during the war. By the end of 1942, most of the Italian settlers in Libya had left. The fighting had destroyed most of the towns, roads, and farms built by the Italians, especially in the eastern part of the country.

At the end of the war, the Allies faced the problem of what to do with Libya. As a reward for the Sanusis's assistance, the British foreign minister had promised them in 1942 that they would never again be subjects of Italy. On the other hand, the Libyans did not particularly want to be ruled by Britain. As an interim measure, Britain administered Tripolitania and Cyrenaica, and France administered Fezzan, while the United Nations debated the question of Libya's future. Most world powers recognized that the era of African colonialism was ending, and—although Italy and the Soviet Union both offered to take responsibility for Libya—the United Nations decided that some means of granting independence should be found. In November 1949, the U.N. General Assembly voted that Tripolitania, Cyrenaica, Fezzan, and the desert between Fezzan and Sudan should become an independent monarchy by January 1, 1952.

With the help of the United Nations and British and French advisors, Libya drew up a constitution. In 1950, a national assembly of the Libyan people overwhelmingly chose Idris, the head of the

Rommel led German and Italian forces in Libya in World War II.

British troops celebrated the recapture of Tobruk from Rommel.

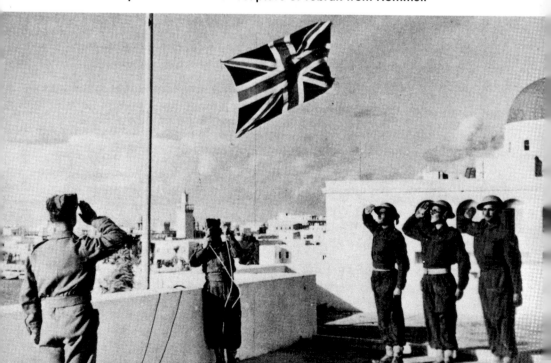

Sanusiyah and the grandson of its founder, to rule the new nation. On December 24, 1951, King Idris I declared Libya independent.

The king's rule was absolute and prohibited political parties, but each of the three major provinces had its own parliament under the constitution. Although formally unified for the first time in their history, the provinces remained separate in some ways. People thought of themselves as Cyrenaicans, Tripolitanians, or Fezzanis, not as Libyans. Tripolitania was more cosmopolitan and less fundamentally Islamic than Cyrenaica, with very few Sanusis. In fact, Tripolitania had consented to join with Cyrenaica primarily because the British had promised to free the Sanusis from the Italians.

As Grand Sanusi, King Idris made it clear that he preferred to live in Cyrenaica. He started to build a new capital, Baida, on the site of the original Sanusi zawiyah near the ruins of Cyrene–but the capital eventually moved to Tripoli because Tripoli was already an established center of government and business. A quiet and retiring man by nature, Idris grew increasingly devout. Although the government continued to share the Western (European and American) point of view in most international affairs, Libya joined the Arab League in 1953 and refused British troops permission to advance on the Suez Canal through Cyrenaica in 1956.

By the mid-1960s, King Idris was in a strange position. Western governments were unhappy with his rule because they felt that he had become an ally of the Arab nations, but many Libyans felt that he was too favorable to the Western countries. The nomadic desert tribesmen did not distinguish between the British and the Italians–

they hated all Europeans equally, and many of them regarded Idris as a puppet of the detested foreigners. They also resented him for policies that they felt favored wealthy aristocrats and landowners.

Idris's failure to unify the country became more serious when Libya discovered huge deposits of oil in Tripolitania and Cyrenaica. Western countries wanted the Libyan regime to provide them with oil, Arab nations wanted Libya as an ally, and the Libyan people were increasingly determined to obtain a share of the wealth for themselves. When oil production began in earnest in 1961, government services expanded, building programs began, and the standard of living started to rise. But, although they were located on Libyan soil, the oil wells belonged to foreign corporations, particularly those of the United States and Great Britain. Some Libyans began to feel that their country was not receiving as much of the profit from the oil as it should have.

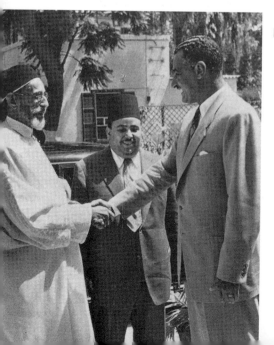

King Idris and Egypt's Gamal Nasser shared political views.

Those who wondered whether King Idris's government would remain stable also worried about his probable successor. Idris was old and ill, and his nephew and heir, Crown Prince al-Hasan Rida, lacked his uncle's experience and abilities. Many observers both within and outside Libya feared that he would be an inept ruler. In less than a decade, Libya had transformed from an almost feudal group of poor provinces into a wealthy, modern monarchy. It was a time of great change in all aspects of Libyan life, and some people began to desire still more changes. Students, laborers, and young army officers in particular opposed Idris's rule. Libya was ripe for revolution. On September 1, 1969, a swift, well-planned coup d'etat (overthrow of the government) led by a 27-year-old army officer named Moammar Qaddafi deposed King Idris I of Libya.

Moammar Qaddafi was born in 1942 in the tent of his nomad parents somewhere in the open desert of the Sirtica. He has never revealed the exact date and place of his birth, because he regards these as mystical secrets. Qaddafi's grandfather, father, and brother had fought against the Italians, although they were not members of the Sanusiyah. From them he learned to distrust all foreigners.

His desert origin later helped make Qaddafi popular among Libyans. They regard the Sirtica as a frontier region, something like the Old West in the United States, and most modern Libyans respect the image of the cowboy-like bedouin. Also, because Qaddafi was not associated with any of the three main provinces, he appealed equally to people from each of them.

At 14, he went to school in Sabha, in Fezzan. There he studied *Philosophy of the Revolution* by the pro-Arab Egyptian Gamal Nasser,

51

who preached that politics alone could not bring about change in society and that violence was necessary to improve the lot of oppressed peoples. As a teenager, Qaddafi spoke often of revolutionary plots and the need for the Arab peoples to unite against Soviet and Western nations.

The first official meeting of Qaddafi's revolutionary movement took place in 1963. Recognizing that most successful coups are carried out by military forces, Qaddafi decided to join the Libyan army. He enrolled in the military academy in 1964 and rose to the rank of captain over the next several years. In 1966, he spent six months in England as part of a training course. He returned to Libya with a strong hatred for the British and the Americans.

As Qaddafi's military career advanced, so did his revolutionary plans. He was the leader of a cluster of young servicemen who called themselves the Free Unionist Officers. They scorned King Idris and all Western influences and strictly obeyed the Muslim requirements for prayer, fasting, and chastity. By 1969, they had secretly recruited the majority of Libya's 7,000 soldiers to their cause. Qaddafi believed that they were ready to topple the government and awaited the most favorable opportunity.

An unexpected complication arose when an older officer approached Qaddafi and hinted at a conspiracy to overthrow Idris and install Prince Rida on the throne. Realizing that if he didn't act, the other group of conspirators would, Qaddafi put his long-planned coup into effect early in the morning of September 1, while King Idris was out of the country at a Turkish health resort. Under the command of 60 young officers who were fiercely loyal to

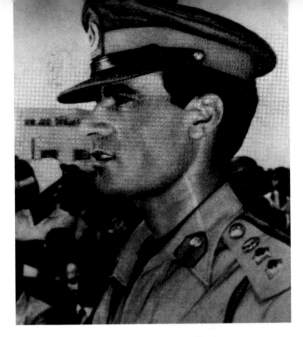

Qaddafi joined Libya's army to fulfill his plan for revolution.

Qaddafi, revolutionary troops seized military installations, government offices, and radio and television stations in Tripoli and Benghazi. Although Qaddafi later claimed that the coup was bloodless, foreigners who were in Libya at the time reported gun battles at the Idris Airport in Tripoli and at a police station in Benghazi. The coup was over in less than four hours, and Moammar Qaddafi suddenly found himself the most powerful man in Libya. He promoted himself to colonel on the spot, and took the official title "revolutionary leader." In keeping with the image of the humble desert Arab, however, Qaddafi asked his people to call him simply "Brother Colonel." He appointed himself acting head of the General People's Congress, the legislative body of the new Socialist regime.

Qaddafi quickly evicted British and United States forces from military bases in Libya. He forced oil companies that wanted to do

53

business in his country to give Libya 51 percent of control and profits—and took over a few companies entirely. He instituted new laws designed to enforce strict Muslim and Arab customs. He gave orders to arrest women who wore pants or short skirts and men with long hair. He banned blue jeans. He ordered all signs in English or Italian removed from public places, permitting only Arabic script, even in locations such as airports, which made travel confusing for non-Arabs. He closed Western-style businesses—Qaddafi himself led a raid on a notorious nightclub in Tripoli and scared away the patrons by firing a few rounds from his revolver into the ceiling.

Qaddafi broke Libya's ties with Britain and the United States and sought unity with other Arab nations. At various times, he began treaty negotiations with Egypt, Tunisia, and Sudan, but his would-be allies rejected his proposals. He provided money and military training to the Palestine Liberation Organization (PLO) and other groups and nations in conflict with Israel. He also supported terrorist "liberation movements" in Northern Ireland, the Philippines, Central Africa, and the Middle East. In 1979, Qaddafi sent troops to Uganda to try to save the regime of the infamous dictator Idi Amin, who later sought sanctuary in Libya. Qaddafi's soldiers also intervened in civil wars in Chad, Libya's neighbor to the south, in 1980 and 1983.

In 1977, Qaddafi announced that he had renamed Libya the People's Socialist Libyan Arab Jamahiriyah (*jamahiriyah* means "government through the masses" in Arabic). In 1979, he formally stepped down from his position as head of the General People's

Qaddafi officially aligned Libya with other Arab nations in 1971.

Congress—although he claimed that it was the will of the people that he continue to hold the supreme post of revolutionary leader. But there were signs that Qaddafi's control of the country was slipping.

Some outside intelligence services estimate that the Qaddafi regime has jailed or executed as many as 3,000 Libyans, many of them students, for expressing "incorrect" political opinions and that 100,000 Libyans have fled the country. During the early 1980s, Qaddafi's name appeared in headlines around the world when several prominent Libyans living in Europe who had criticized the revolutionary leader and his policies were assassinated, possibly by Libyan "Death Squads."

55

Qaddafi made the headlines again in March 1986, when he ordered Libyan air missiles to strike American warships for crossing the "Line of Death," a boundary line he drew in international waters in the Gulf of Sidra. The following month, American fighter planes bombed military targets in Tripoli after receiving evidence of Qaddafi's responsibility for bombing several European airports and a West Berlin disco.

Qaddafi's losses were political as well as personal. His failure to make a good military showing against the Americans cost him much prestige among his people, some of whom had already lost faith in his regime. Although Qaddafi's government carefully edits all news from Libya, it is believed that several failed assassination and coup d'etat attempts targeted Brother Colonel in the late 1980s.

In 1993 the United Nations approved sanctions against Libya for the part Libyans took in the terrorist bombing of Pan Am flight 103 over Lockerbie, Scotland in 1988 and for harboring the suspects in the bombing. An embargo was placed on trade and air traffic which was then tightened, freezing some of the country's overseas assets. The UN sanctions have continued throughout the 1990s. These sanctions and the world view of Libya as a terrorist stronghold isolated Libya in the international community.

The hard line taken against Libya by the international community actually served to strengthen Qaddafi politically in Libya because the difficulties are viewed there as caused by Libya's enemies, especially the United States.

The People and Their Ways of Life

Libya's three million inhabitants reflect the lasting influence of the massive Arab migrations from the east in the 11th century. Approximately 97 percent of Libyans are Arabic-speaking Muslims of mixed Arab and Berber descent.

Although the Arab-Berber Libyans are members of the Caucasian (white) race, they are often quite dark-skinned, espe-

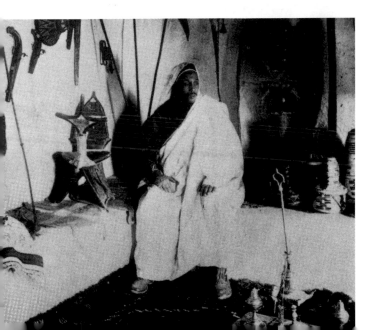

This desert-dweller's home displays many Libyan handicrafts.

cially in the southern regions of the country, where the Berbers did not intermarry with Phoenician, Greek, or Roman colonists. In other respects, the Libyans share many physical characteristics with the people of southern Europe and the Middle East. They are usually of medium height, with dark brown eyes and brown or black hair.

A few pure Berbers remain scattered throughout the southern oases, and about 50,000 of them live in the valleys of the Jabal Nafusa. These Berbers are also Caucasian and look very much like other Libyans. They continue to speak their native language, although many of them speak Arabic as well, and they have adopted the Arabic alphabet. Although the Berbers are Muslims, their form of Islam contains some elements from primitive religions of the region and from early Christianity. These elements include allegiance to local saints, belief in the magical powers of holy places, and the performance of magic ceremonies, including a ritual believed to bring rain. Berber women have traditionally had greater freedom than is granted to women among most Arab peoples. They may divorce and remarry and own property. Tribal laws and customs still govern these aspects of Berber life, although the remote tribes are gradually integrating into modern Libyan society.

As a result of the trade in slaves that was carried on across the Sahara until the 18th century, some black Africans from Sudan and the countries south of the great desert settled in Libya. Today there are about 35,000 blacks in the country, most of whom live in Tripolitania and Fezzan and work on farms. Although some

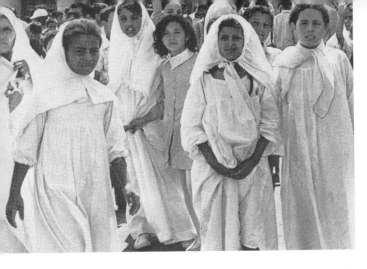

Libyan women often enjoy more freedoms than other Arab women.

Libyan blacks have retained their original central African languages, most also speak Arabic and have become Muslims.

After several hundred years, the 35,000 descendants of the *kouloughis*, the children of Turkish soldiers and Berber women, remain a distinct ethnic group within Libya. They have Turkish names, and many of them speak Turkish as well as Arabic. A few of them have blue eyes—a legacy of the Russian soldiers who were recruited into the Turkish Army centuries ago. Since Turkish times, the kouloughis have traditionally been well-educated and have formed a secretarial and clerical class in some parts of the country. They tend to live in and around the major cities.

The smallest ethnic group in Libya is formed by the Tuareg people, members of an ancient desert people from the southern Sahara. Some Tuareg remain scattered through the more remote regions of North Africa, the Saharan oases, and northern Niger and Mali. In Libya, a few Tuareg tribes live in the southwest, near the oases of Ghudamis and Ghat. They speak their own language,

59

called Tamahaq, which they write in special characters known as *tifinar*. Although they have adopted Islam the Tuareg remain strongly attached to ancestral customs. For example, they pass down inheritance rights through the mother instead of the father, so that a young man receives the property of his mother's family, not his father's. Tuareg society is almost medieval in structure. The *amenokal*, or chief of a league of tribes, rules, supported by the *imrad*, or vassal noblemen. A tribe of workers and craftsmen, the *inanden*, ranks below the imrad, and black servants occupy the lowest rung of Tuareg society. In earlier times, the blacks were slaves of the Tuaregs, who still refer to them as *iklan*, the Tamahaq word for "slave."

The Tuareg call themselves the *imuhar*, or free men, and have resisted becoming part of any organized government or urban settlement. They are careful to distinguish themselves from the Berbers by wearing turbans and cloaks of black or dark blue—Berber tribes wear white. Because the Tuareg men and women veil their faces at all times, they are sometimes called "the people of the veil." The women also decorate their faces with patterns of tattoos in dark blue ink. Tuareg from all over the Sahara meet at great fairs in the desert every year or so. There they barter for livestock and other goods, and the young men take brides. Tuareg tribes live by herding camels, goats, and hump-backed African cattle and by guiding trading caravans through the desert. Years of severe drought in the Sahara, however, have reduced the Tuareg to extreme poverty. Many of them may soon have to settle in villages and work on farms in order to survive.

One ethnic group has all but vanished from Libya. Before World War II, more than 30,000 Jews lived in the country. They specialized in trade and handicrafts and were concentrated around Tripoli. The increasing power of Islam in Libya made the country hostile to Jewish residents after the war, and by 1970 all but 620 of them had left Libya. Qaddafi expelled even this small remnant of the Jewish population.

A number of foreigners live in Libya, although no one outside the country knows how many or who they are. When Qaddafi came to power, the foreign community included about 20,000 Egyptians, 14,000 Tunisians, 10,000 Palestinians, 10,000 Americans, 5,000 Italians, and some Turkish, Greek, British, and French citizens. Qaddafi has ordered all Americans and Europeans, except those needed to operate the oil companies, out of the country. Egyptians and Tunisians left Libya when Qaddafi quarreled with the leaders of

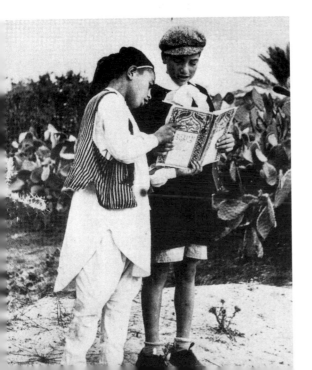

A Libyan boy shows his friend from Italy how to read Arabic.

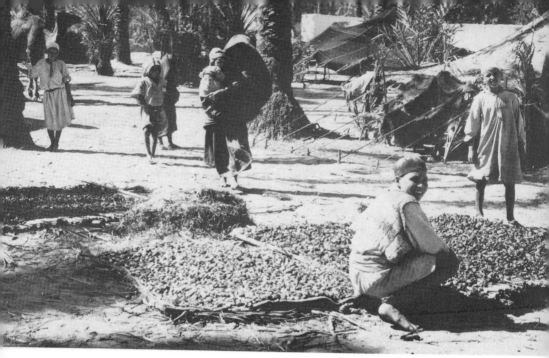

Bedouin preserve old ways, and many remain outside Libyan society.

their countries. Today, only minimum diplomatic staffs remain to represent most other nations in Libya.

Three groups of people in Libya today follow age-old ways of life and remain set apart from the rest of society. They are the bedouin, the Sharifs, and the Marabouts.

The name "bedouin" comes from Arabic words meaning "people who become visible"—referring to the bedouin tents that often are the only signs of life in a bleak landscape. Bedouin tribes live by choice in the most remote and unsettled parts of Arab countries, scorning the settled life of the farmer or the "soft life" of the city dweller. Traditionally, they have no use for education and follow a primitive form of Islam. Today, most bedouin are nomadic

62

herdsmen, although in the past some were bandits who preyed upon travelers and caravans. Bedouin society is organized around the family and tribe, and many bedouin feel little identification with their country. But although they relish their austere life and harsh environment, the bedouin are becoming fewer in number. Most Arab countries, including Libya, officially discourage the bedouin way of life and hope to settle desert-dwellers on farms or even in cities. In Libya, many bedouin men have become oil-field workers, policemen, or soldiers.

The Sharifs are holy tribes that organized in Fezzan. They claim to be descended directly from Muhammad, the prophet of Islam, and have great status among Muslims. Many Libyans believe that the Sharifs have divine powers, including the ability to foresee the future. The Sharif tribes are also comparatively wealthy and own many large tracts of cultivated land in the western oases.

The Marabouts are descended from holy men who also claimed to be related to Muhammad. Their ancestors arrived in Libya from Algeria, Tunisia, and Spain during the 14th century. The first Marabouts lived in the desert as religious hermits. Some were dervishes (holy men subject to spells of wild dancing and chanting) or were credited with supernatural powers. In places where the local inhabitants welcomed their teachings, the Marabouts settled and founded tribes. Today, their descendants continue to practice a traditional form of Islam.

Tripolitania is the most cosmopolitan region, with the highest proportions of pure-blooded Berbers and of people descended

from black Africans, Europeans, or Turks. It is also the most populous—72 percent of Libyans live in Tripolitania, 23 percent in Cyrenaica, and almost 5 percent in Fezzan. The remainder—less than one percent—are the isolated Berber tribes people of the southeast, who are gradually migrating northward to the oasis of Kufrah or to the cities of Cyrenaica to find employment.

Long ago, Libya was a land of tiny, independent farms, where each family tended its own livestock, raised what crops it could, and had little contact with others except at trading fairs or regional markets. Where farming was not possible, as in Fezzan, nomads roamed with their flocks and herds in search of fresh pasture, and each family had its own traditional grazing area. Small villages of no more than a few hundred people formed around oases or the forts that protected the caravan routes. Foreign conquerors and traders inhabited the coastal cities, while the Libyans remained a rural people.

The migration of Libyans from rural areas to cities is one of the most important changes to take place in Libya since its independence. Libya is now one of the most urbanized of all Arab nations. Nearly 85 percent of its people live in Tripoli, Benghazi, and a few other cities. The others remain in the country, although almost all of them now live in large villages or small towns of 2,000 or 3,000 people.

Although they live in cities, most Tripolitanians work in commercial farming, traveling from their homes out into the irrigated fields of the Jefara every day. Most farmers have their own plots of land, which are usually quite small. They sell their produce to

shop owners or large markets in the cities. In Fezzan, desert or rock outcroppings divide many farms into three or four tiny patches of cultivated land, and the farmers seldom have much produce to sell after their families have been fed. In Cyrenaica, a tribe or local government, instead of an individual, generally owns the land, and livestock herding is more common than farming, except along the coast.

As Libyans become more familiar with the modern world and more accustomed to a higher standard of living, many of them are eager to make a living in some way other than farming or tending livestock. They flock to the cities for jobs, but most lack the skills necessary to work in the oil industry or in other technical fields. Government planners are concerned about the massive migration from rural Libya to the towns—they fear that too few young people will continue to work on farms to feed the country. Plans are under way to build more schools and hospitals in rural areas so that their inhabitants will be less likely to move to the cities. In addition, the government offers bonuses and interest-free loans to farmers. These programs may halt, or even reverse, the flow of people from the outlying districts to the coastal cities.

Tripoli, Benghazi, and Other Cities

Between 1954 and 1966, the population of Libya's cities grew by more than 25 percent each year. Since 1966, the rate of urban growth has continued to increase each year. More than one-quarter of all Libyans now live in cities with populations greater than

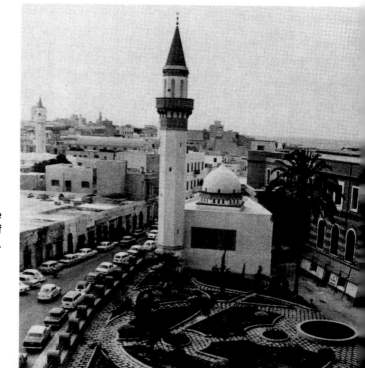

This Islamic mosque in Tripoli is typical of many in Libya.

100,000. The largest cities are Tripoli (with more than 590,000 people) and Benghazi (448,000).

Tripoli is Libya's capital and main port. Its harbor receives most of the goods imported into the country, including equipment for the oil industry and consumer products, such as electronic components and clothing. Tripoli is Libya's business and commercial center as well. The Bank of Libya has its headquarters there as do most of Libya's financial institutions.

Although Tripoli is a very old city, the government has rebuilt much of it in recent years. Modern office buildings, hotels, and apartment buildings have replaced many ancient buildings. The large residential districts contain thousands of two- and three-story rowhouses. The luxurious suburb of Giorgimpopoli, to the west of the city, is a collection of colorful, terraced gardens and tile-roofed, pastel villas owned by wealthy Libyans and foreign businessmen. Less fortunate citizens live in large, slum-like shanty-towns of tents and shacks that have sprouted up on the city's outskirts and are spreading in all directions. The government is trying to build low-cost housing for the many rural people who have come to Tripoli, but construction cannot keep up with the migration to the city. The residents of these poor districts face serious sanitation and water supply problems.

Among the old buildings in Tripoli that remain are many fine examples of Islamic architecture, mostly mosques, or Islamic temples. The Karamanli rulers built a great number of ornate mosques in the 18th century, and most of them survive today. They are decorated with mosaics made of hundreds of thousands

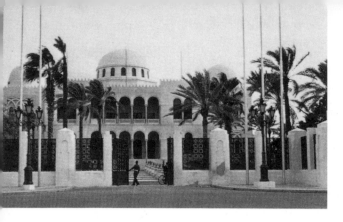

King Idris's former palace now houses government offices.

of painted tiles set in geometric patterns. Although the city has become modernized and now has Western-style skyscrapers and tree-lined boulevards, the skyline still shows Tripoli's Muslim heritage. White-domed mosques share the sky with graceful, tapering towers, or minarets, from which priests cry out the signal for Islamic prayer.

The palace that once belonged to King Idris is now an important office building for the new Socialist government. Other government buildings are concentrated in and around Tripoli, and many military posts are located in the city and its suburbs. Qaddafi and his family live in a heavily guarded army base in nearby al-Aziziyah.

Libya's second city, Benghazi, is also surrounded by military installations and airfields. It, too, is a busy port with both wealthy citizens, who live in the southeastern suburb of al-Fuwayhat, and poor ones, who live in extensive "suburbs" of tents and huts. Somewhat less modern and Westernized in appearance than Tripoli, Benghazi is growing almost as fast as the capital.

Tobruk, Libya's third-largest port, has an excellent natural har-

68

bor but is located in an arid, sparsely populated region. The city has grown since the discovery of oil in 1959, and now a pipeline runs 320 miles (515 kilometers) from a major oil field in southern Cyrenaica to Tobruk. At the port, workers load the crude oil onto ships bound for Europe and the rest of the world. Tobruk also has several small food processing plants and serves as a major trading center for Kufrah and other Cyrenaican oases. In the desert outside the city are three cemeteries where the Allies buried French, British, and German soldiers during World War II. They made no cemetery for the Libyan soldiers who died in the war.

Tripoli and Benghazi have experienced most of Libya's urban growth since 1951, but a few other cities have populations of

Benghazi, Libya's second-largest city, is rapidly expanding.

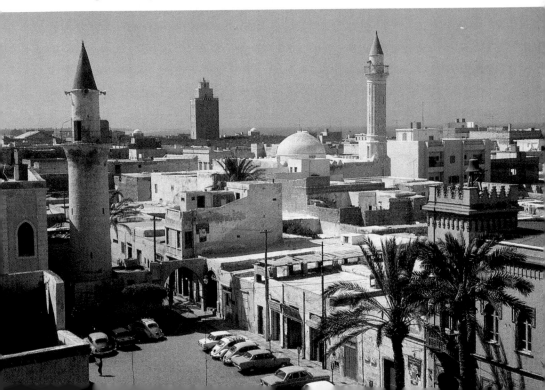

more than 5,000. The cities in Tripolitania are Gharyan, al-Khums (or Homs), Misratah, Tajura, Jumah, Zanzur, and Zawiyah. In Cyrenaica, they are Baida, Darnah, Marj, Ajdabiyah, and Tobruk. All are old settlements, except for Baida and Marj, which were founded during King Idris's reign. The government has developed Misratah and al-Khums as ports, and may expand the harbors at Darnah and Tobruk if the oil trade increases.

Although small, Sabha is the largest town in Fezzan and the administrative center of the area. Before Libya achieved independence, Sabha was a poor village of sun-baked mud huts. In 1951, a wealthy local leader named Ahmad Saif an-Nasr decided that Fezzan should have a city to compete with the coastal metropolises. He built the first stone house in the region and helped win government funding for an agricultural school, a hospital, and asphalt streets. The government built regional offices in Sabha, and soon a bank followed. Growth has slowed, but Sabha remains the most modern settlement in southern Libya. Sabha is also an important trading and market center for the farmers and bedouin of the region. Camels are more common on its streets than cars, and many residents still dwell in houses of mud brick thatched with dried palm fronds.

Libya is extraordinarily rich in archaeological sites. The coastal regions contain many examples of Greek, Roman, and Turkish architecture.

Whole cities, now ruins, preserve in marble and sandstone the early history of the Mediterranean settlers along the northern

70

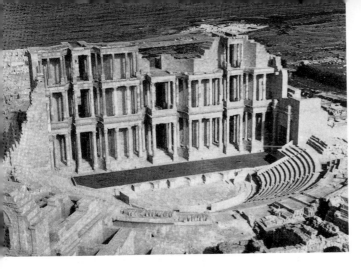

Romans built this theater in Sabratha about 800 years ago.

coast. The largest ancient city is Leptis Magna, near al-Khums in Tripolitania. Still farther west, near the Tunisian border, lie the ruins of Sabratha, including a vast Roman amphitheater, or circular, open-air theater, from the second or third century A.D. It is decorated with many life-size statues of gods and heroes, and most of its hundreds of tall columns still stand, although the statues and columns have been scored and blasted by wind and sand.

The Romans also constructed a huge, marble arch in a stretch of empty desert on the Gulf of Sidra. Its exact date and purpose are unknown, although it probably honored a victorious military commander.

The site of ancient Cyrene contains many Greek ruins, including temples, storehouses for grain, and stone-paved roadways. Archaeologists have found coins and painted vases identical to those of Athens and Sparta among these ruins.

In the deserts to the east are many isolated tombs, some in the form of small pyramids, like miniature versions of the famous royal tombs of Egypt. The remains of very old Berber cities in the

71

far eastern regions of Libya suggest that the region was once more fertile and densely populated than it is today, but archaeologists must conduct much scientific study of these early sites before they will unlock their secrets.

One of Libya's greatest archaeological treasures is its rich trove of Berber and Saharan ruins and relics. These fragments of the past may one day shed light on the kingdoms and civilizations that flourished in the Sahara thousands of years ago, before the great desert conquered the region. Unfortunately, skilled scientists using modern methods have never fully explored Libya's archaeological sites. Only in the years between the two world wars and during Idris's reign did Libya welcome archaeologists. Qaddafi's coup and later hostility to foreigners disrupted archaeological excavations, and most international scholars and scientists consider Libya off-limits today.

Many of the items found by early archaeologists and amateur excavators have made their way into museums or private collections around the world. Those that remain in Libya are in the care of the Department of Antiquities, which maintains an Archaeological Museum and a Museum of Natural History in Tripoli, as well as special museums at Leptis Magna and Sabratha. The department also conducts some excavation in Cyrenaica, at the sites of the ancient cities Ptolemais and Apollonia. A small museum in Sabha displays relics of early Fezzani life and culture.

Government, Social Programs, and Communications

Libya has a Socialist government. In theory, the principles of socialism call for all workers to have political power and to share in the country's resources and profits. In practice, however, power in Libya rests with the revolutionary leader and his 12-member

Local chiefs in Tripoli plan community development programs.

Revolutionary Command Council. Other political bodies within the country, such as the General People's Congress, cannot take any action without the approval of the Revolutionary Command Council.

Both men and women have the right to vote in Libya, but only local elections have occurred since Qaddafi's 1969 coup. The General People's Congress is a legislative (law-making) body of varying size. The Revolutionary Command Council appoints its members and also appoints 16 members to the General People's Committee, which functions like the United States cabinet. The committee members, or ministers, are in charge of such departments as defense, antiquities, agriculture, and transportation.

There are two complete sets of laws and court systems: one for traditional Islamic law, called the Shari'ah courts, and one for criminal law. The Shari'ah courts handle civil matters—lawsuits, property claims, business and family disputes—according to Muslim traditions. The criminal court system includes a court of appeals. One Supreme Court serves as the court of final appeals for both systems. The General People's Congress appoints judges, who serve until age 65.

Although the three large regions of ancient times have retained their identities, for purposes of local government Libya today is divided into 10 *muhafazat*, or states. They are Tripolitania, Benghazi, Sabha, Baida, Gharyan, Misratah, az-Zawiyah, al-Khums, Darnah, and al-Khalij (the last includes Surt, Ajdabiyah, and the Kufrah oasis). The Revolutionary Command Council appoints a *muhafiz*, or governor, to administer each state, assisted

by 31-member committees containing nine representatives of government departments, 18 representatives elected by local citizens, and four representatives of the Arab Socialist Union.

The muhafazat are further divided into a total of 25 *baladiyat,* which are something like the counties of the United States. The baladiyat, in turn, contain the smallest units of government, the *mahallat,* which are towns or tribes. A *sheikh* (chief) or *imam* (religious leader), who has usually inherited his role in the community, governs each town, although elections are becoming more common. From the states down to each tribe, the goal of regional and local government is to strengthen the people's identification with the new nation of Libya. The Libyan flag—a square of plain green—flies from every government building, school, and hospital. Enormous portraits of Qaddafi hang in every public place, showing him in either the white robes of a desert bedouin or Western-style military uniforms.

Under Qaddafi's rule, the armed forces have played an ever-increasing role in Libyan politics. Many officers, particularly young followers of Brother Colonel, hold council and committee posts. The army now numbers about 35,000, the air force 22,000, and the navy 9,000. The country's police force is called the Security Force. It is believed that some groups within the military forces have tried unsuccessfully to wrest control away from Qaddafi, their commander-in-chief. As far back as the Roman Empire, when military commanders often seized the imperial throne, history has shown that soldiers often overthrow leaders who rise to power on the shoulders of the army. Perhaps hoping to prevent such a reversal, Qaddafi

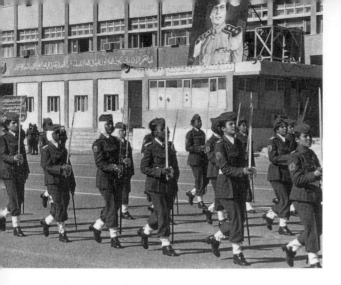

Libyan women train at a military academy in Tripoli.

began in 1986 to share some of his authority with the country's top two or three military leaders.

Over the past 40 years, both Idris's and Qaddafi's governments have spent large amounts of money to improve the health and well-being of the Libyan people. Much of the wealth oil has brought into the country has gone into a program of socialized medicine, under which all medical care and medicines are free.

In 1971, Libya had only one doctor for every 692 people, and one hospital bed for every 260 people. Although health care has improved, there are still too few hospitals and doctors to provide good care for everyone in all parts of the country. Exact figures are not available, but it is thought that only Tripoli and Benghazi have adequate, up-to-date hospitals. The government is building and gradually establishing clinics and health centers in the smaller towns and oases.

Many foreign doctors have left the country or been expelled by

the Qaddafi regime, and Libya has no medical school. Students sometimes find it difficult to attend medical schools in other countries because their primary education is weak. In addition, religious customs that bar women from contact with men other than their husbands have kept many Libyan girls and women from being trained as doctors or nurses, although that custom is beginning to change.

The chief health problems are tuberculosis, eye diseases (such as trachoma), and bilharzia, or schistosomiasis (a parasitic infection of the liver or intestines usually spread by infected drinking water). Modern medicine has brought malaria under control. The life expectancy has risen in the past few years from 37 years to 65 years.

The previous low life expectancy results were not only from diseases that strike adults but also from infant mortality. In the early 1970s, Libya had one of the highest rates of infant mortality in the world. In some regions, as many as 300 out of every 1,000 babies died. The government has made a special effort to educate women (particularly in remote regions) about sanitation, nutrition, and child care. In addition, nearly 500,000 children receive food supplements at school or at home. As a result, the infant mortality rate has dropped to 56 deaths in 1,000 births.

The government operates the National Social Insurance Institute, which provides free benefits, similar to social security, to Libyans too old to work. Government workers also receive maternity benefits, dental care, pensions, and life insurance—social programs that were unknown in Libya before the 1950s.

All newspapers and magazines published in Libya are in the official language, Arabic. The government owns some of them and closely censors even the independent publications. It does not permit criticism of Qaddafi or his regime. Libyans see few foreign publications, especially outside Tripoli or Benghazi. The government regards those foreign publications that do make it into the country as subversive. A Libyan could go to jail—or at least be called before the Security Force—for possessing an issue of the American magazines *Time* or *Newsweek*.

All radio and television stations are owned and operated by the government. Radio Libya has two stations in Tripoli, one in Benghazi, and one in Baida. Programs are broadcast in Arabic and French. Television stations in Tripoli, Benghazi, and Sabha broadcast news and religious and educational programs in Arabic.

Economy, Resources, and Transportation

Libya had been a prosperous trading center for the Greeks and Carthaginians and the granary of the Roman Empire, but it became a poor country after centuries of Arab and Turkish rule. The Arabs introduced huge herds of livestock and a nomadic way of life that destroyed much of Fezzan's fertile land, and the Turks allowed the ancient irrigation systems to fall into disrepair. When Libya became independent in 1951, its economic prospects were grim. The average annual income was the equivalent of $45 U.S. (the local currency is the Libyan *dinar*), and the country had almost no resources. During the next decade, the new nation survived on a combination of foreign aid and rent paid by the United States and Great Britain for the air force bases they maintained there.

The discovery of oil changed that. In 1956, the Libyans found oil near the Algerian border. Beginning in 1959, they mapped extensive oil fields throughout the Sirtica and Cyrenaica. Foreign

Oil pipeline is prepared for extension across the desert in Libya.

oil companies moved in to tap these underground reserves, which were estimated to hold as much as 28 billion barrels. Libyan crude oil has proven to be especially desirable because it has little sulfur. This means that it causes less corrosion and pollution than most crude oil does and is easier and less expensive to process.

When the Suez Canal closed in 1967, Libya became the oil-producing country closest to Europe, and its petroleum became even more valuable. By 1970, it was the fifth-largest producer and the third-largest exporter of crude oil, and the Libyans's average annual income had increased to nearly $2,000. But because so many people wanted to earn money in the new oil economy, they abandoned their farms and agricultural production dropped. The country had to import more than 60 percent of its food.

Looking ahead to a time when the oil reserves would run out but people would still need to be fed, Qaddafi's economic plan-

ners began allotting large sums to agricultural development. The budget for 1971 set aside $140 million for this purpose, as compared to only $36 million in 1969. Although oil makes up 99 percent of the nation's exports, it is not Libya's only resource. Oil deposits often are accompanied by natural gas, another powerful energy resource. The country started to develop natural gas plants to exploit this resource when oil prices began to drop in the early 1980s. Natron (hydrated sodium carbonate, a useful industrial chemical) exists in Fezzan, potash and sulfur in the Sirtica, and gypsum, manganese, and some coal in Tripolitania. Deposits of chalk, marble, and limestone dot the country, particularly in the Jabal Nafusa.

After declining during the 1970s, agricultural production began to increase slowly, as many farm workers who could not find jobs in the oil fields or the cities returned to farming. The major crop today is cereal grains, especially barley, which adapts well to different

Libya's agricultural production is increasing slowly.

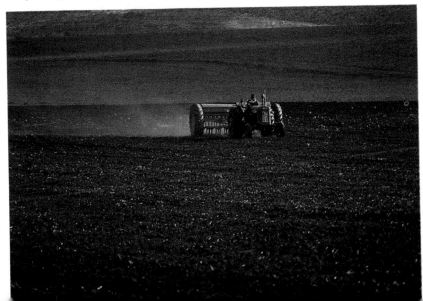

weather conditions and types of soil. Wheat grows on the Jefara, sorghum in Fezzan. Olive plantations, some of them as old as the Roman Empire, are numerous throughout Tripolitania, as are tobacco farms and orchards of citrus fruit, almonds, and figs. Dates are Fezzan's biggest crop, although farmers cultivate beans, peanuts, and grapes as well. Electrically-powered pumps provide irrigation in the northwest, but in the oases of Fezzan many farmers still use the *dalu*, a goatskin bag pulled over a pulley by a horse or ox.

Hoping to create some areas of forest in a land almost entirely without trees, Idris's government planted more than 27 million acacia, cedar, cypress, eucalyptus, and pine saplings between 1957 and 1964. It is not known how well the forestation projects have succeeded.

Herdsmen raise cattle, sheep, goats, horses, and camels in Fezzan and Cyrenaica. Because pastureland is scarce, the government's agricultural advisors are trying to encourage them to shift to crop cultivation—one acre of land can feed more people with grain, fruit, or vegetables than with the animals that can graze on it. Many of the nomadic and seminomadic tribes of the east and south, however, continue to travel with their herds.

Libya has little industry other than petroleum operations. Most factories are located in or near Tripoli, and most are quite small. Nearly 90 percent of the factories employ fewer than 100 people, and more than half of them employ fewer than 50. Food and beverage processing, leather working, and iron and steel production are three of the country's other industries. Government-sponsored

factories also process esparto grass and salt, and produce cigars and cigarettes, rugs, and cloth (from imported materials).

The fastest-growing factories are those that support the petroleum industry by manufacturing steel drums, tanks, and pipe fittings. The construction industry is also growing rapidly, as native workers take over jobs formerly carried out by foreign contractors.

Although few Libyans eat fish, a small fishing fleet operates off the Tripolitanian coast, catching tuna, sardines, and red mullet for export. The government licenses Greek divers to harvest the many sponge beds in Tripolitanian waters.

Since 1963, Libya has enjoyed a favorable trade balance. It sells more products to other countries than it buys. Qaddafi's expensive military purchases, such as fighter planes bought from a French manufacturer, have depleted the country's cash reserves, and the slump in oil prices has reduced its income. The economy is no longer growing at the rapid rate of the early 1970s, and Libya must exercise careful budget control if it is to avoid financial setbacks.

Both King Idris and Colonel Qaddafi realized that a good transportation system was vital if the independent regions and remote villages of Libya were to be united into a strong country. Even the Italian colonists before Idris saw the need for a network of reliable roads. The major road-building program since the 1980s has greatly increased the highway system.

Today, Libya has about 52,650 miles (81,000 kilometers) of roads, of which about 30,000 miles (45,400 kilometers) are paved.

Umbrellas protect pipeline welders from Libya's desert sun.

Work proceeds on an
irrigation dam in
Benghazi.

The main highway runs for 1,100 miles (1,760 kilometers) along the coast between the Egyptian and Tunisian borders, with branches to the coastal towns. The Sabha highway runs from the coastal highway south to Sabha in Fezzan and then southwest to Ghat, near the Algerian border. Another highway runs from Sabha south to the borders of Chad and Niger. Highway development has been the number one priority of the department of transportation.

There are few private automobiles, which Libya must import, though their numbers have increased since the highway improvements recently made. Most of them belong to government officials or oil company executives, although most towns and villages have a few old trucks and jeeps. Trucks and vans that transport food, livestock, and other goods from one end of the country to another are the primary road users. Libya has no railroads and none are planned.

Tripoli and Benghazi have international airports where airlines operate flights to and from Egypt, Lebanon, and Tunisia. Restrictions on air travel because of the UN sanctions in the 1990s have severely curtailed travel to and from Libya. Security at Libya's airports is extremely strict. Armed guards thoroughly question and search non-Libyan travelers upon arrival. Smaller airports at Sabha, Baida, Ghudamis, and Ghat serve Libyans traveling within the country.

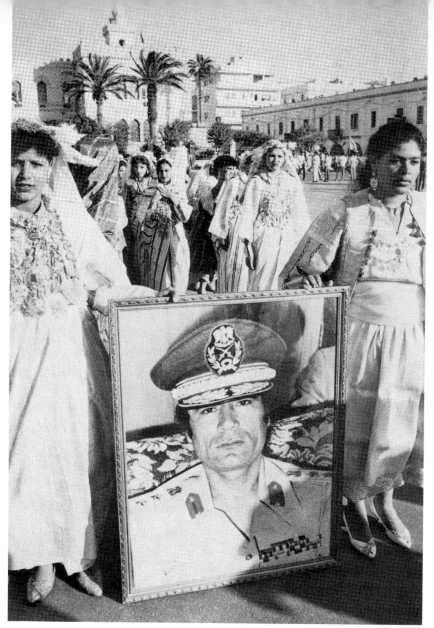

Holding Qaddafi's portrait, students march in traditional garb.

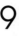

Culture, Customs, and Education

The cultural life of the country has two sources: traditional Berber folk arts and crafts and Islamic religious art and customs. The traditional arts of the Berber people include metal engraving, leather work, rug weaving, embroidery, and pottery. Ancient Berber craftsmen decorated their wares with crude, lively geometric shapes, usually triangles and zigzag lines. These patterns, in shades of brown, rust, and dark blue, still appear in some of the rugs and embroidered cloth sold in rural markets. When the Berbers converted to Islam, much of their art took on the Arabian style called *arabesque*, characterized by intricate, flowing, curved lines. Libya, like other Arab nations, has no tradition of painting because Islam forbids the creation of images of people or animals. (Flowers, however, appear in many Arab rugs and carvings.)

Music in Libya combines the Berber tradition of the wandering poet-singer, whose songs celebrated popular heroes or historic events, with Arabic instruments such as drums and cane pipes

(flutes). Most Libyan songs consist of simple melodies played over and over, with slight variations or additions.

Until the 1960s, most Libyan literature was religious, consisting of interpretations of the Koran, the Islamic bible. Since then, however, some Libyans have begun to write poems, histories, and even novels. These works are usually strongly nationalistic in tone, presenting an idealized view of Libyan life and politics and sometimes showing contempt for other cultures. They are published in Arabic and are not widely available outside the country.

Libyans still practice traditional cultural events, such as festivals, folk dances, and horse races. Through the departments of information, education, and national guidance, the government encourages people to participate in such activities and provides funds to pay teachers of native dances and crafts. The al-Fikr Society, an organization of professional and intellectual men, also supports the arts.

Islam pervades every aspect of daily life in Libya. As in all Muslim countries, the people kneel to pray five times every day (daybreak, noon, afternoon, sunset, and night), facing the Arabian city of Mecca, the holy city of Islam. To signal the time for prayer, priests called *muezzins* climb to the tops of the tall minarets and chant. (Many muezzins are blind men, chosen so that they cannot look down from their high perches into the private courtyards and rooftop gardens below.) Libyans frequently mention Allah, or God, in conversation. For example, a man announcing his intention to travel from Tripoli to al-Khums will add, "*Inshallah*" ("If

Allah wills it"). The title of the national anthem of Libya, *Allah Akhbar*, means "Almighty God."

Although Libyans celebrate many Islamic holidays, the most noteworthy is the month of Ramadan. During Ramadan, Muslims cannot eat, drink, or even smoke from sunrise to sunset. They eat a large meal just before dawn and another just after sunset. Many businesses close in the afternoon, and parades, fireworks, and processions are common late at night. Although Muslims consider Ramadan the month of fasting, they consume more food then than at any other time of year, because at night they make up for what they cannot eat during the day. The Libyan government strictly enforces the rules of Ramadan, and will fine anyone who breaks them, including non-Muslim visitors and travelers.

Since ancient times, the basic unit of social organization in Libya has been the *qabilhah* (tribe). Even today, although the

A Tuareg nomad plays bagpipes made of animal skins.

Students learn the Koran by copying each line onto boards.

country has a centralized government, eight of every nine people in Libya continue to recognize their tribal relationship.

All the families in a qabilhah claim a common ancestor, and all members of the tribe acknowledge the authority of the sheikh, or chief. Sometimes several qabilhahs consider themselves joined in a *leff*, or confederation of tribes, most often because their founders were related or came from the same place.

Many Libyans regard the *bayt*, or family within the tribe, as the smallest social group. It is much more extensive than Western families usually are, as it includes three or even four generations. Each individual considers his aunts, uncles, and cousins to be as much a part of his family as are his parents and siblings. The oldest or wealthiest man of the bayt has patriarchal authority over all other members. Even in the largest, most cosmopolitan cities, the oldest man of a large, extended family commonly collects the earnings of all the family members and distributes them as he sees fit. The bayt always cares for older family members.

Western-style dating is almost unknown in Libya. Social con-

90

tacts between young men and women almost always take place at family gatherings, and senior male bayt members arrange most marriages. As more and more young people attend school and find work in offices and factories, however, married couples are beginning to break away from the large family group and set up independent households in government-sponsored apartments. And although all family relationships are dominated by men, a few women are finding jobs, especially in the larger cities. Traditional tribal society may give way to a more Western way of life if the bayt continues to break up into smaller, single families.

Traditional customs also mingle with Western ways in the area of fashion. About half the Libyan people, including most inhabitants of the rural districts, dress in Arab *djellabas* (white, full-length robes) and turbans. The style in which a turban is wound and the knot used to tie it vary from region to region and follow very ancient traditions. Other Libyans, however, wear Western-style clothes, usually in dark colors. Some compromise by wearing djellabas over their Western attire. Women do not have to wear veils over their faces as in some Muslim countries, but many do so anyway.

One aspect of daily life that remains traditional is food. Libyan cuisine reflects a strong Arab influence and has relatively little in common with the food of nearby southern Europe. Popular dishes are *shakshouka*, a dish of chopped lamb and tomato sauce topped with an egg, *babaghanoug*, a paste of sesame seeds and mashed eggplant seasoned with lemon, garlic, and spices, and *mouloqiyah*, steamed vegetables with rice. A typical meal for guests might consist of huge bowls of rice, beans, and mutton placed in

91

the middle of each group of six people, to be scooped up with thin, flat bread.

Since 1951, King Idris and then Colonel Qaddafi have spent a large proportion of public funds on education. Libya had no public education until then, although the children of foreign residents and some wealthy Libyans attended private schools. Today, public school is free and all children—boys and girls—must attend for six years of primary education. Most children do attend, except for some rural and nomadic families who live too far from the nearest schools. The government has built primary schools in isolated parts of Fezzan and Cyrenaica.

Students who want to continue their education can attend three years of intermediate school, followed by either three years of secondary school or vocational training for a trade or craft. The Al-Fateh University has campuses in Tripoli and Benghazi, and the

Teachers use audio-visual aids in a rural school in Libya.

Enrollment in Libya's universities is increasing.

government pays for the education of qualified students. A special branch of the university in Baida provides advanced religious training, for which the government also pays. All teaching at all levels is done in Arabic.

In addition to the regular primary, intermediate, and secondary schools, the government supports about 100 traditional Koranic, or religious, schools, which young boys may attend after their regular school hours. These schools use a centuries-old system to teach the Koran, which many Arabs know by heart. A scholar sits in the middle of a circle of boys and recites the Koran from memory, over and over, taking many days to complete one recitation. The students learn by listening and join in when they are ready.

In 1949, the entire country of Libya contained only 16 college graduates, and 90 percent of the population could not read or write. By 1970, 3,000 young Libyans were attending college at home or abroad, and between 30 and 40 percent of the Libyan people had learned to read and write. The government has established special programs to train new teachers and provide adult education to combat illiteracy and literacy has risen to 76 percent of the population.

10

Libya and the World

Because of Libya's brutal climate and daunting terrain, for centuries the outside world knew very little about it. Even in this century, the Ottoman rulers discouraged travelers from visiting the region. Conditions are surprisingly similar in the 1990s. Libya does not welcome travelers, and news and information from within the country are often obscure, sometimes distorted by government propaganda. To Westerners especially, Libya is a land of mystery—and an enemy. Most people remained uninformed about the country until recent years. To them, "Libya" is synonymous with "Qaddafi."

It is important to remember, however, that there is more to any nation than its leader. Today's Libya is a country of ancient customs and new money, of old regional cultures still at odds with a new national structure. Like many other new nations in Africa and Asia, Libya is struggling to find its identity at home and its place in the world. Whatever its political future may be, Libya will continue to play an important role in world affairs.

GLOSSARY

bayt	A family unit within a tribe
bedouin	Desert nomads
beys	Local rulers
dervishes	Holy men subject to spells of dancing and chanting
foggara	Ancient irrigation systems of subterranean tunnels some of which can still be found in the deserts of Libya
ghibli	Intensely hot wind that blows northward from the heart of the Sahara carrying huge quantities of sand and dust
kouloghis	Descendants of Turkish soldiers and Berber women
leffs	Loosely organized groups of tribes
mehari	Fast riding camels
pasha	Regional king under the sultan
qabilhah	Tribe
sabkhahs	Salt lakes that form when seawater accumulates behind sand dunes and then evaporates

Tamahaq	Language of the Tuareg tribes
wadi	Dry valley that carries water for a few months only during the rainy season
zawiyah	Monastery of the Samusiyah, an Islamic brotherhood

Index